Three
Whiskeys
Deep

Solar Return Edition

xx Neghar ♡

written and illustrated by
Neghar Fonooni

All words and illustrations by Neghar Fonooni
Book design by Aimée Suen
Author photo by Homer Parkes

Alchemized in Los Angeles. Printed in the United States.
Find out more at saltandsorcery.shop

"The cosmos is within us. We are made of star-stuff. We are a way for the universe to know itself."
—*Carl Sagan*

"Luminous beings are we,
not this crude matter."
—*Master Yoda*

Contents

Lost + Found: A Solar Return

My writing process is not especially structured or linear. One might even describe it as chaotic and slightly unhinged—I am, in many ways, at the mercy of the Muse.

The words come to me on their own time, often unsolicited, without consideration for things like "schedules" and "deadlines" and other such earthly constructs.

The Muse has her own pace.

And so, when a portal opens and the messages come through, I scribble poems into notebooks, punch spells out on my vintage typewriter, and hastily type prose in the notes app on my phone.

When that portal closes, I compile all of those notebooks, scraps of paper, and digital musings into an offering, into a book. It's how I've written all three of my books thus far, and it's how I imagine I will continue to write for as long as the pen will have me.

Except, when I compiled the offerings in *Three Whiskeys Deep*, I inadvertently left out eight poems—eight messages from the same portal as the existing forty-seven within the book. When I found these poems in a wayward notebook, I knew they needed to join the others—they could not possibly find a home anywhere else.

Naturally, I set out to create a second edition of the book with these lost (and found) poems—a *solar return edition* to celebrate the book's first trip around the sun. In doing so, I became inspired to include new illustrations as well. The aforementioned Muse had her own ideas of what this offering should look like and so this is where we've arrived together:

Three Whiskeys Deep: Solar Return Edition is an offering of fifty-five poems and fifty-five accompanying illustrations, designed to emulate oracle cards. Each illustrated "card" was channeled through the energy of its host poem and includes a line from the poem itself.

My books have always been best consumed by flipping to a "random" (not random) page, much as you would pull an oracle or tarot card. There is a serendipity to my writing process that lends itself seamlessly to the reading process as well. And now, that structure is built into the book itself.

Thank you for receiving this offering and giving it a place to live on your bookshelves, altars, and sacred spaces. Flip to any page, and trust that it's exactly where you're meant to be.

xx
N

What I Know Most of All

Under the influence and under the stars, I find myself asking, "when does it get good?"

I lean, precariously, over the edge of the abyss. I twist in my sheets and question the nature of my existence. I wonder if I'll always be alone. I wonder if I've ever been.

The thing about whiskey (which is the same thing about all elixirs) is that it soothes the aching in my bones, but only because it asks me first to confront them. Only because it demands I submit myself to the hunger of the night sky. Only because it's a portal. Only because it's a spell.

There are so many layers I've peeled back in the months I wrote these poems—a plethora of demons unmasked, a belly full of exhales. I've met myself for what feels like the first time.

I've done that again and again.

I have gazed at the moon in all her phases and spoken softly to the stars. I have stared into the fire for longer than I've ever stared at any singular thing. I have abandoned the idea that my pain is unique, because I know that you too have been three whiskeys deep, looking to the cosmos for some kind of respite, doing everything you can not to float away.

What I know most of all, at least in this moment, is that despite the overwhelming temptation to feel otherwise, I am most certainly not alone in this uncertain place. I take comfort in knowing that when I stare up at the stars, seeking answers, seeking solace, so many others are doing the same. Perhaps you. Perhaps now.

Three Whiskeys Deep is a journey into the void—a collection of poems, moon spells, and illustrations, conceived late at night, scribbled frantically into notebooks or typed voraciously on a 1958 Olympia SM4.

The only way I've ever known how to navigate life is by writing and creating, and so it stands to reason that the pages that follow are an exploration of our shared cosmic DNA—an urgent whisper into the Universe, into your heart:

Maybe there is more to this than flesh and bone. Maybe no one does it alone.

Maybe if we can look to the moon and see ourselves reflected in a 4-billion-year-old astral body, we'll see that we too have a place in this world, a place among the stars. Maybe we can find comfort in the cosmos, in messages channeled from the Universe into paper and ink.

Maybe we're going to be okay.

With Love + Salt,
Neghar

Time has always been a spiral

m theory

time has always been a spiral
time has always been a spell
time has never lived
within the confines
of our fabricated rules

but now
in the age of covid 19
time almost ceases to exist

time has been made
 irrelevant

and the universe takes a bow

dear universe

I had just clawed my way out of one
abyss, and you ask me to descend into
another?

I had just come out of my hermit shell
and you ask me to retreat once more?

I had just begun to stand in the light
and you ask me now to walk with new
shadows?

you ask and I oblige
for who am I to fight you?

I am a bag of bones and blood
on a spinning rock
in infinite space—

who am I to question cosmic jokes?

who am i to
question cosmic jokes?

into, the void of
promises unkept

asleep in the center

you once told me the bed sank in my
absence—my body a fixture of your
slumber

and now my heart sinks into the
mattress

seeps through the springs that have
begun to uncoil, into the void of
promises unkept

the smell of your skin still fresh upon
the linens, the taste of your mouth
fading quickly,

and my body a relic of your memory
as the eighth night closes in.

it's okay if you're not okay

carved out
to the depths of me
hollow
and under fed
I am the ghost
and the sheet that drapes it
I am alone
as the world prepares
to meet its end
I am without
I am within

the ghost and the
sheet that drapes it

somewhere in between

tethered

gently holding on
to anything that keeps me
 here

not clinging
not floating
somewhere
 in between

burn

little notes
kept in a jar on my altar
vestiges of you,
rolled up and held sacred
airtight and untouched
by the tempest

I offered them to the fire

one by one I read them
your words felt hollow
as I mouthed them

one by one I burned them
the careful angles of your pen
devoured now by flames

what use have I for such treasures?
what space have I for such trash?

**devoured now
by flames**

offer things to the fire

slower

66 degrees
and I turn on the fireplace anyway
I pour a glass of basil hayden's
on the rocks
I stare into the fire for longer than I've
ever stared at any singular thing
I cry about things I didn't know
I needed to cry about
I offer things the fire that
I didn't know
I needed to burn

the quiet has made things louder
the quiet has made things slow

 slower
 still

there aren't any answers
there might not be questions either
there is nothing but now
when time moves this slow

nocturnal

you and I had 3 am
our incipient stage of bliss
the honey
the sweat
the rapture

we laughed until we kissed
we kissed until we slept
we spent the day after feeling
mostly dead
but strangely alive

I never thought I'd find 3 am again
I swore that kind of nocturnal magic
was lost to me
forever

last night I discovered 5 am
this time it was honest
this time it was slow

3 am is yours to keep
keep it bottled up
keep it swept under
whatever callous rug you've woven

let it rot there
let it die

mostly dead but
strangely alive

even in this crisis
i am saying yes to joy

sleep in peace when day is done

it was a good day in a string of
good days
the sun in April is eager and
my scars have aged to silver
and even in this crisis I am saying
yes to joy

supermoon

charge your crystals cast your spells
offer something to the fire
offer something to your soul

stare into the abyss for longer
than you should and be ready
for what stares back
consider the ways you've been
hiding from veracity
from yourself

confront the things you've
been avoiding confront
the demons at your door

there is nowhere to go and nothing to
do and no one is coming to save you
but the moon is bright and the veil is
thin and magic is alive in every moment

(and when all else fails, there's whiskey)

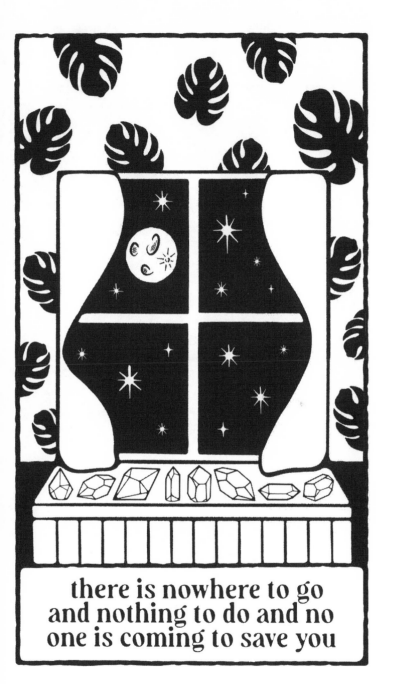

there is nowhere to go
and nothing to do and no
one is coming to save you

no aces up
our sleeves

for keeps

we knew the game was rigged
and we played it anyway

no aces up our sleeves
we came out hot
brazen hearts and agile bones

we played for keeps in a world
where nothing lasts

forever

scraps

pieces of you hidden
in every crevice
pressed between pages
whispers of a pen gone dry

they startle me when I find them
ghosts coming out of the shadows
ghosts without a home

they don't frighten me
the way they did in july
they don't bring me to my knees

they go promptly into the fire
into ash
into ember
into nothing but a wisp of smoke

(will your ghost ever make
its way to the grave?)

whispers of a
pen gone dry

all of them are mine now

big house

it really is a big house

bigger than I'd ever noticed
when the echoes
of your laughter
filled its ample spaces

big enough for a family
big enough for roots
big enough for the memories
we never got to make

four chairs at a table
every morning
I choose a different one
all of them are mine now

nothing is ours

pictures of two kids
attached to the fridge
I take one down
I am alone in the big house

I am alone in all things

scar

there are stories you only tell
when you're naked
lying in the wake of it all
in the sheets
in the sweat
in the tenderness of exploring
each other's bodies—
it's only then that you trace
the shapes
noticing the details

tell me about this tattoo
tell me about that scar

the story of the scar on my left hand
is a story I've told
before there was you

and now
as you lay in different sheets
and different sweat
tracing the scars and tattoos
and curves of some other
I know I could never tell that story
again

tell me about
that scar

my heart is the hearth

warm

I don't need your body
to keep me warm at night

I lit our bed on fire
and consumed the embers

my rage is the flames
my heart is the hearth

fracture/fix

when you left
you took pieces of me with you
maybe they were the pieces
I wasn't meant to keep

pieces i wasn't meant to keep

wish i could
remember the last

saturnalia

december came back around
and december was hard
it dug up the bones of new love
and late nights raucous laughter
and records flipped
you shook up a bottle of cheap
beer and drenched me in its
foam — I knew you had a secret
behind your lips:
"there's something you're not
telling me"

that was the first time you told
me you loved me
I wish I could remember the last

mornings

mornings begin at 9 now
sometimes 10
sometimes 2
some nights endure
well into the darkness

I pour another glass

I stand naked on the balcony
under rain falling
under the moon calling

mornings begin much later
because time has lost all meaning
this much is true

but the night
has things to show me
things to teach me
things it wants me to know
that can only be known
when the sun has given leave

the night has
things to show me

time devours
everything

time

time devours
and time detangles
and time reveals
and time heals

everything
and always

forget about your house of cards

we committed an act of arson—

burned down the walls between us
that seemed solid but in the light
shone thin as rice paper, wrapped
around yellowfin tuna, drizzled
with

ponzu sauce

burned down ideas of what
should and should not be,
rejecting convention, rewriting the
rules, vandalizing the places where

conformity lives

burned down old narratives
ripping out pages, writing new
stories, on fresh pages, with

fancy pens

we committed an act of arson so
that we might be wild and free,
fully uncaged, loose from all
bridles, monsters in a world that
favors movie stars, misfits among

the masses

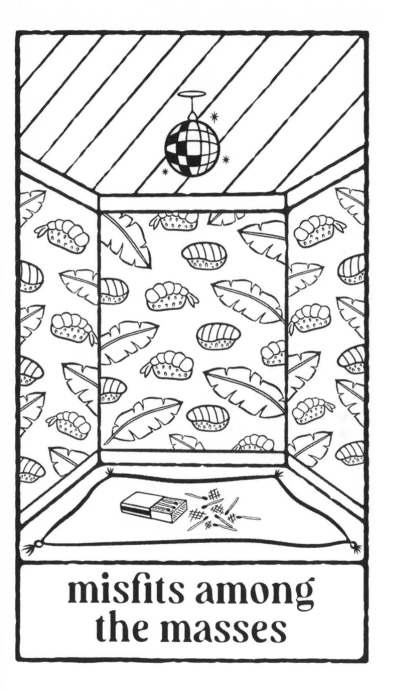

misfits among the masses

scorpio full moon

this one is spicy
 sharp
 jagged around the edges

this one is a dagger
this one is a spell

there is a darkness here
it offers a portal
the other side is fresh
 clean
 squeaky

but first
 bloody
 raw

first you must wield a mirror
a reflection of the most
 wretched
 within

the wounds parched
with duct tape
with super glue

the other side is fresh

a keepsake of the strolls
i took through the shadows

many skins

I have to tell you
that this was the year
I came back to myself

I have to say it out loud so that I
can see the words take shape in the
sky
and know that they're real—
the way I know magic is real
the way I know we are
stardust

 personified

I have to tell you
that this version of me
is one who has cosmically

 surrendered

one who has burned it all down
and cackled in delight at the ghosts
dancing in the flames
they're just as dead as they are
part of me

 in perpetuity

I have to tell you
that I saw the maelstrom coming
from miles away
and while at first I turned and ran
bags packed and weapons drawn
I chose instead to stop
and let it take me
to let it open my wounds and
 bleed me dry

to let it break me open and
 rub me raw

I have to tell you
that I've shed more skins
than I'd been taught we were
allotted—

that each skin
with its gossamer scales
showed me a glimmer of myself
a keepsake of the strolls
I took through the shadows

I'm ready for what comes next

 I just had to tell you

traveling

we've always known that
no one owns the stars but
what about the moon?
could I be so bold to
claim her dark side for
myself?

would you share it with me?
would you come with me
to the darkest places?
would you come with me
to the shadows

to the edge of all things
where magic holds its breath
where whispers lie waiting
to tell you that you must float
into outer space
if you ever want to find
your way home?

no one owns
the stars

too strong for such endeavors

marrow

there was a time
when I would have eaten
my own marrow
if it made space for you
to live within my bones

and in the time since
my bones have grown
too strong
for such endeavors

where are you when
you're not here with me?

where do you go at night? where do you
go when the stars plot their capers when
the moon is holding court? do you lie
flat on your back and whisper secret
wishes into the void? do you twist in
your sheets and wonder if you'll always
be alone? do you stare into the darkness,
searching for the edges of the veil,
desperate to peel one back, hoping
for a glimpse of something cosmic?
where do you go when the shadows
are dense? do you find comfort in the
darkness?

do you think the stillness is a spell?

hoping for a glimpse
of something cosmic

that's how i know
i'm healing

heal

I'm sad at home by myself
sometimes
but I'm not sad in public
anymore
and that's how I know
I'm healing

first kiss

I know the world is burning
and panic has gripped the globe
I know I should be worried
I know I should be scared

but the only thought I can conjure
is the soft and subtle meeting

of our lips

the breathless moments between kisses
when I know that in spite of yourself

you feel it too

that quiet magic
that sweet surrender

the breathless
moments between

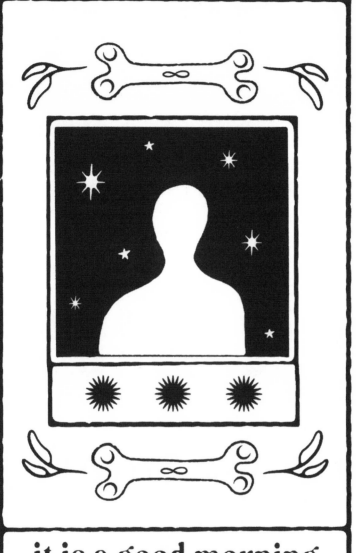

it is a good morning for burying bones

bones

it is a good morning to wake up to the song of birds, in the absence of traffic, in the stillness of this new world.

it is a good morning for old vinyl and black coffee and a tiny sliver of sun, on a 3x6 south facing balcony, in a big empty house in west LA.

it is a good morning to dredge up ghosts—to shake them loose from their graves to stare into the hollows of their eyes and ask, "do I know you? do you remember? am I ready to let you die?"

for the days are short and the nights stretch into the void. there is new magic and even as the moon hid behind the clouds she gave birth to this morning— she lingers still, unseen.

I look at a photograph of
your face and I see nothing.

it is a good morning
 to thank you for
leaving.

it is a good morning
 for burying bones.

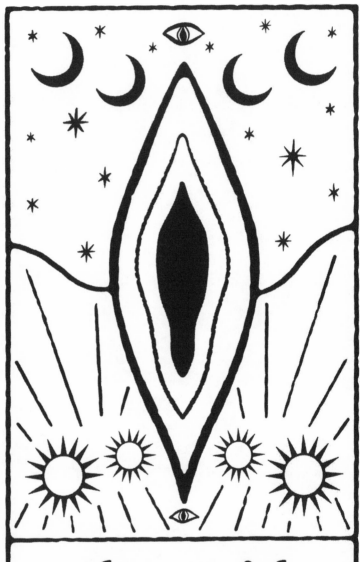

the void

oblivion

I walk into a room
I forget why I am here
I walk off the edge of the earth
I remember who I am
everything lost
is found again

 in the Void

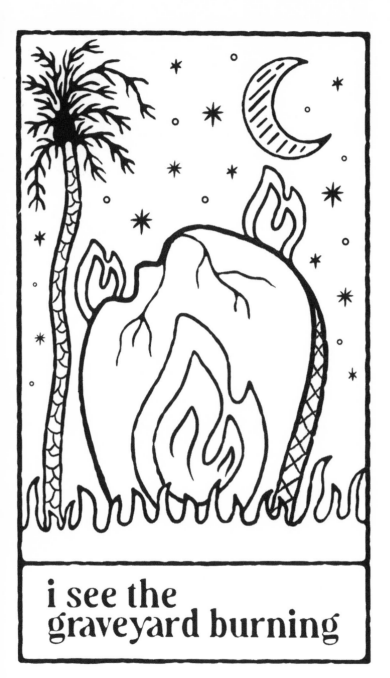

i see the
graveyard burning

graveyard

I made an offering to the fire
last night

whiskey has a way of making
me nostalgic when I've drank
one too many
when the potion runs deep
enough to reach
the bones
the places where you live
the graveyard of our life
together

it used to be that only love
lived there
gravestones adorned with
adulations
But last night I saw the twisted
the murky
the macabre—
the times you were cold
and silent
the eggshells I walked upon to
preserve your fragile eco system
the way you watched me crisp
around the edges
without remorse

the way you fed me nothing
but crumbs
the way I let myself
be fed them

in a notebook you'd given me
I wrote them down
each memory I could conjure
both the beauty and the broken
every blessing every curse

page by page I penned them
ripped them from the spine
offered them to the fire
watched them catch
watched them burn to ash

I know it won't be the last time
your ghost pulls salt
from my eyes
but I feel the end coming
I see the graveyard burning

every night I am closer
to the fire

you can't take it with you

early morning never belonged
to you

3 am, laughing almost too
much, always too loud
never wanting dawn to be

 so near

lazy afternoons,
wedged discreetly between
a respite from outside monsters
alone in the Universe

 of our bed

those were ours
those belonged to us

but I never met you in the
sacred stillness of dawn
6 degrees below the horizon
I never met you in the softness
of first light, when god is quietly
afoot

I have never seen you there and
so that is where I must go.

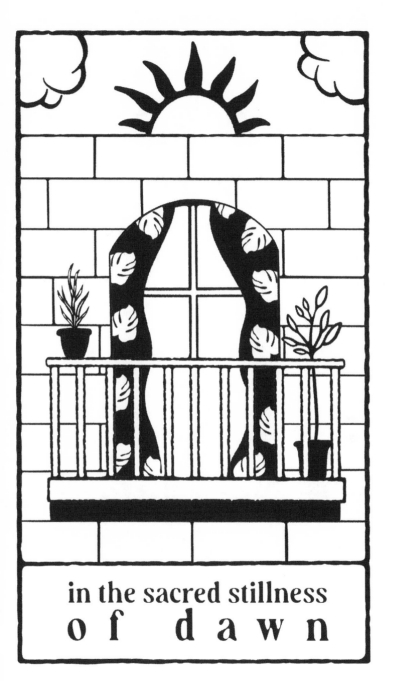

in the sacred stillness
o f d a w n

we are here
we exist
we are real

taurus new moon

root your feet onto the earth
thrust your hands into the dirt
take care of a plant
take care of your heart
take care of our planet as she
spins
into the ether
take a deep fucking breath
and another
and another

maybe you feel lost
and maybe you feel
untethered
but the moon is dark
and the earth is spinning
and we are here
we exist
we are real

we are of the stars
and we are of this earth
and we will keep going
until we turn to ash
and return to the great mother

ash + alchemy

underneath it all
you are blood and bone
 just like me

underneath it all
I am ash and ember
 just like you

you according to
your wounds
me according to mine

we spend a night
together
in something
 purgatorial
something
 in between

we do it again
we do it some more

wouldn't it be sweet
to peel back layers
wouldn't it be better
to dare to want more

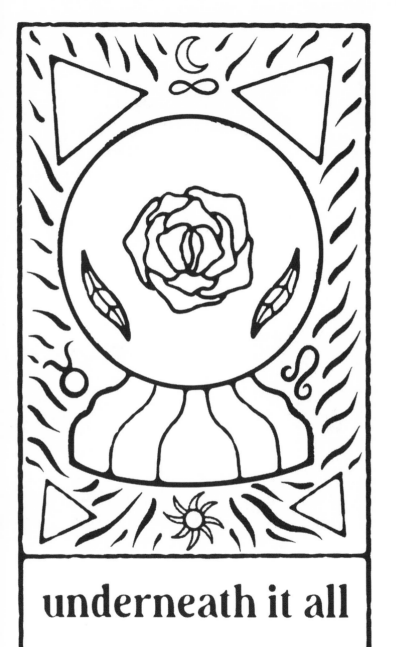

underneath it all

the night does not yield

what it's like
to sleep without you

every hour of the darkness
wants to meet me

every fear that lives
at the edges of my soul
comes out to play

old bones
new maladies
the night does not yield
the night comes to shatter
the night remembers every
anxious thread

pulls them loose
smirks as they unravel

and I am come undone
nothing left to do but
 succumb

is it still called waking
when sleep evades?

maybe it was real

maybe you really did love
me until you just couldn't
 anymore

and that's all there is
and all there ever was

all there is and all there ever was

pray it isn't poison

risk

everything can be a portal
everything can be a spell

bottle up a potion
pray it isn't poison
 instead

maelstrom

I broke into pieces
and came back together
more luminous
more sage
than ever before
I set fire to old costumes
discarded my masks
bent metal, tore paper
shattered glass
picked up the shards
clutched in bleeding hands
the pieces that still served me
put them together
jagged and raw
unsure of what the new
amalgam would reveal
gave myself permission
to wax and wane
fall apart and make myself
whole again
slithered out of one skin
and into another
begged my shadow
not to ossify
whispered to my heart:
stay just as soft as you are
strong

**stay just as soft
as you are strong**

i have never stopped
wanting to go back

a public display of affection

there was one night
in the early days when
you kissed me
up against a wall so urgently
my red lipstick smeared
across the contours of
your cleanly shaven face
I have never felt as wanted as I did
against that wall
I have never stopped wanting
to go back

logophilia

it's been so long
since I've sat at this typewriter
so long since my fingers
have punched out
a spontaneous
shitty
poem
long enough that I question
if I remember how

but then

my fingers hit the keys
I hear the familiar *click*
of the type bars
against the platen
and the words take
shape on paper
and the words take
their first breath
their first steps

when something lives
within the marrow
of your bones
it makes itself
impossible to forget

impossible to forget

and tonight i scarcely remember

stranger

last year
on this night

I would have burned
down the sky
set fire to every star
I would have plucked
the moon
offered it to some
horned god
just to bring you home

and tonight I scarcely
remember you at all

solstice

the moon, the earth, the sun
come together in alignment
and so too must we
so say we all

we are the whole of the cosmos
 incarnate
here to demand justice
here to burn the system
to the ground

even if it means we must cry
into the night even if it means
we must scream into the void
again
and once more

say your prayers
cast your spells
march with feet in rhythm
march with fists raised

statues will topple facades will
crumble the old ways are dying
the old ways will die

we will not back down
we will not back down
we will not back down

we are the fire and we have
come here to lay waste

the old ways
are dying

Rest up
and drink

there is work to be done

bone tired
and blood thirsty
I scream into the void
I beg for some reprieve

the stars whisper:
rest up
and drink

your time is coming
your time will come

the only truth I know is you

tonight Jupiter shines bright
even in the city
Saturn shows her rings
she does not blush
under the influence and
under the stars
it occurs to me
that more than one thing can
be true at once

two things can
be true at once

one day we will
turn to dust

ephemeral

we are of the stars
and we are of this earth
and both of those are true

one day we will turn to dust
 turn to ash
return to the cosmos
return to the earth
 beneath our feet

but for now we are tasked
with being magic
 incarnate

for now we must do the work
 of
magicians
for now we must cast spells and
mix potions and offer up our
blood and sweat to the coven
 to the collective

for now we must do
what we must
 to survive

3 am

I whispered to the stars
to anyone who would listen
into the vastness of space
into the cracks in between:

I have to do it alone,
don't I?

3 am, part 2

nobody does it alone.
(the stars whispered back)

nobody does it alone

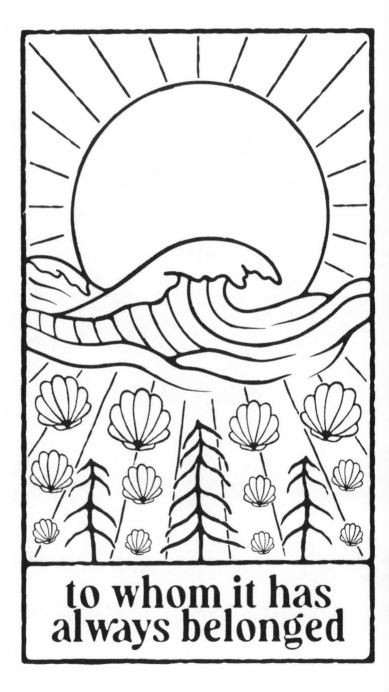

to whom it has
always belonged

offering

I stopped giving my heart
to heartbreakers

but not to keep it bound
within the cavity of my chest

I give my heart instead
to whom it has always
belonged

I give it back to the earth
to a panoply of pines
to an ancient sequoia grove

I give it to the froth of salt
that rides the high tide
I give it to crystal formations
beneath the surface
in the caverns, in the caves

I offer my heart
to the light of the moon
I offer my heart to the stars

layers

I know now more than ever
I'm not meant to live
where the stars cannot be clearly
seen
I'm not meant to live
where the stars feel the need to
struggle

I squint
they squint back
we try so hard to see each other
but there is so much in the way

how much of me remains to be
seen without this
 static
beneath an unpolluted sky?
how much of me
have I yet to meet?

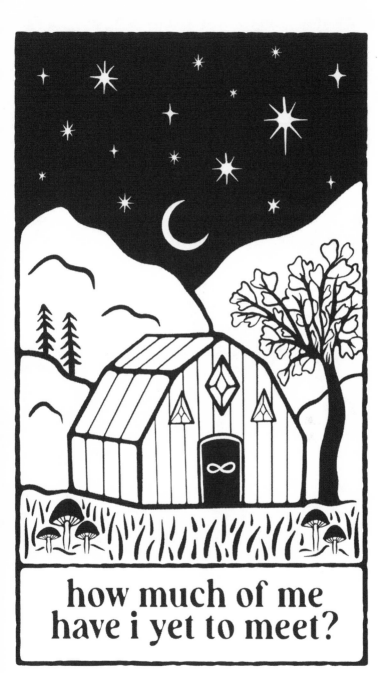

how much of me
have i yet to meet?

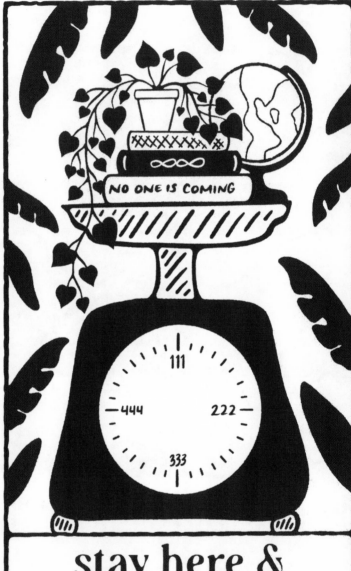

stay here &
stay solid

heavy

if it feels heavy lately, that's because it
is—nothing is like it was before and
yet everything is how it's always been
we've been here before
and we will be here again

the ground feels sticky
it sticks to your shoes
it's becoming harder and harder
to stay calm and stay in it—
stay here and stay solid

it's quite unpleasant
and everyone is tired
everyone feels like they're floating
away
we look for some kind of tether—
in arms and in angles
in bottles and vials

no one does this alone—
that's the only thing that's real and true
the only thing you have to remember
if you can only remember one thing

the same ground up stardust that
makes up my bones makes up yours, too
keep going and know
that we're doing this together
 keep going and know
 that you are whole

syzygy

I always thought
when you went dark
you became unseen

elapsed
erased
eradicated

you'd shed your skin
and wane new once again
invisible to the eyes
of someone seeking
someone shedding
in tandem with you

tonight I sat beneath the
thick and glittered blanket
of an after midnight sky
and I can finally see
that you were in the stars
all along

reflected
revered
renewed

you were in the
stars all along

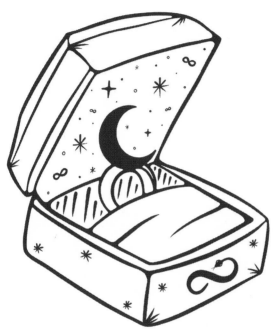

eye to eye with hades

a box made of stardust

I have died a myriad times
lost my breath
and burned my bones
danced on my own grave
eye to eye with hades
hand in hand
with the darkness

if you've died
a thousand times
you know that most deaths
are cleverly cloaked
in the falsehood
 of finality

wounds reopen
and fester
refuse to heal—
until they do

as wounds tend to do
when we give them space
to ooze and bleed
and wield the needle
with which
to stitch
their rough and ruined edges

I was mid death
when you came
tearing at my skin
and praying for sleep

teeth gnashing
bones aching
heart breaking

you brought a box
made of stardust
and filled with
the light of the moon
perpetually unable to receive
 I pushed it away

perpetually refusing defeat
you pushed it right back

placed it gingerly
in my hands
forced me to look inside
tethered me to your sails

 brought me back to life

portal

all is not right with the world
but sometimes a cup of coffee

is a portal

sometimes a puff of smoke

is a spell

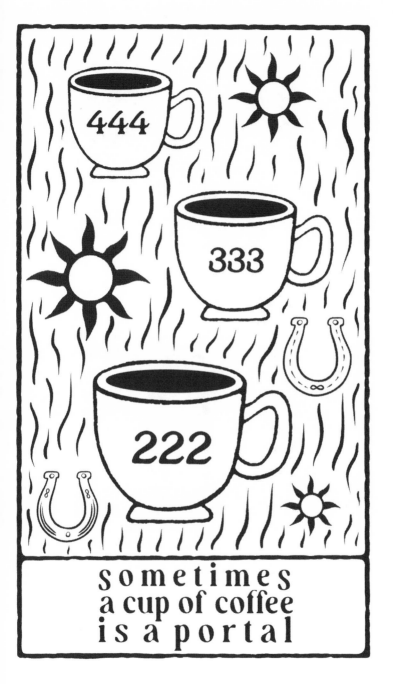

sometimes
a cup of coffee
is a portal

everything hurts
before it heals

eclipse part 1

in the shadow of a different eclipse
in a time that feels like it was maybe
just a dream
I felt myself unravel at the seams—
I watched myself almost float away

In the year since
I have spent many nights under the
moon screaming into the void crying
into a pillow wondering aloud at the
cosmos:

will it ever not be this?
will I ever cease to bleed?

I wouldn't take it back—
not the love learned or love lost
not the full or fractured hearts
not the bellies brimmed with laughter
turned to vials filled with tears

This morning when I woke
I was bleeding no longer
I am transmuted
a level unlocked
a heart reborn again

time devours everything—
everything hurts before it heals
everything can be remade

I am not the same person I was
before the eclipse

eclipse part 2

the earth casts a shadow
and the moon settles in
a cord is cut
a portal closed

a ghost crosses casually
over the veil

on nights like these
ghosts are not resistant

in the morning
all my blood is new

everything within me
fresh
freshly brewed

 a cycle broken

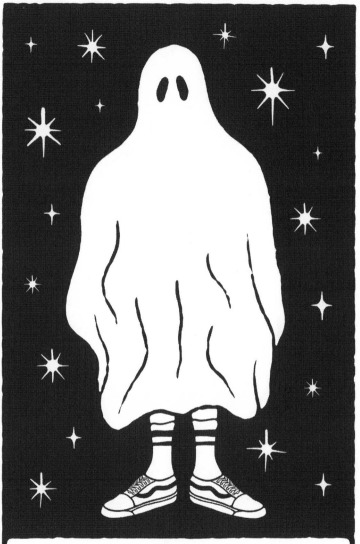

a ghost
crosses casually
over the veil

even after all those
tiny little deaths

79 moons

every night there is jupiter brightest and
biggest and second only to

the moon who has now waned down
to half and she is sliced and sharp and
somehow even soft

and tonight I am stripped bare beneath
her.

there have been nights like these before
and I am starting to remember

how to breathe and how to keep on
breathing and most of all how to say yes
to it all even after everything

even after all those tiny little deaths.

Neghar Fonooni is a word witch, artist, Tarot reader, amateur anarchist, and sentimental stargazer, born and raised in the City of Angels, on Tongva land.

Also the author of *This is Just What it's Like Sometime*s, and *In the Fullness of Time*, Fonooni believes that all art is channeled through the cosmos, messages from the stars that find their way across galaxies, onto our canvases, into the ink of our pens.